THE ROLE OF IMAGERY IN LEARNING

T0159542

Harry S. Broudy

Professor of Philosophy
of Education Emeritus

University of Illinois at Urbana

Occasional Paper 1

The Getty Education
Institute for the Arts

Printed in the United States of America

The Getty Institute for Education in the Arts

1200 Getty Center Drive, Suite 600

Los Angeles, California 90049-1683

Editor: Sylvia Tidwell

Designer: Kurt Hauser

© 1987 The J. Paul Getty Trust

Second printing 1999

Library of Congress Cataloging-in-Publication Data

Broudy, Harry S.

 The role of imagery in learning.

 (Occasional paper/Getty Center for Education in the Arts ; 1)
 Bibliography: p.
 1. Apperception. 2. Visual perception. 3. Imagery
(Psychology) 4. Aesthetics. I. Title. II. Series:
Occasional paper (Getty Center for Education in the Arts) ; 1.
LB1067.B75 1987 370.15'23 88-21521
ISBN 0-89236-145-X (pbk.)

CONTENTS

FOREWORD

The Getty Center for Education in the Arts is pleased to present this monograph by the distinguished educator, aesthetician, and professor emeritus Dr. Harry S. Broudy. It represents the first in a series of occasional papers that the center will issue periodically.

The intent of the Occasional Papers series is to commission eminent scholars and practitioners in art, art criticism, art education, art history, and aesthetics to present ideas that will illuminate and inform the theory and practice of discipline-based art education. This approach calls for the integration of content and skills from four disciplines that contribute to the creation, understanding, and appreciation of art: art production, art history, art criticism, and aesthetics.

It is our hope that this series will add to the understanding of art and its significance in our lives. Dr. Broudy's ideas on the role of imagery in learning are an important contribution.

Leilani Lattin Duke
Director
The Getty Center for Education in the Arts

Summer 1987

INTRODUCTION

This monograph sets forth a theoretical basis for advocating a program of disciplinary arts education as an integral part of general education from kindergarten through grade 12. The title, *The Role of Imagery in Learning*, indicates the centrality of aesthetic perception of images. To make the case, it is necessary to show by analysis, argument, and example the role that images in general and those portrayed in the arts in particular play in (1) everyday experience and (2) the formation of the educated mind.

The roles of imagery in the learning of skills (especially the skills of language), concepts, attitudes, and values are examined to identify points at which the sensory image becomes crucial for understanding. Throughout the essay runs a thread that might be called "the uses of knowledge or schooling." The argument holds that the arts as learned in general education are used associatively and interpretively, rather than replicatively or applicatively. Their function is to enrich the allusionary base, the store of images and concepts that qualify for inclusion in general education.

Although this is not discussed in detail, the theory implies that discipline-based arts education as part of general education must be teachable by the classroom teacher with the same degree of competence demanded by the teaching of other required subjects. This requirement raises the question as to whether classroom teachers can achieve this and calls for a method of preservice and in-service training that would enable them to do so.

IMAGERY AND TYPES OF LEARNING

The role of images is the theme of this essay. It will be discussed as it appears in various styles of teaching: in problem solving, in value education, and in the learning of language. What, then, is the nature of the image? How does it function in ideas, concepts, skills, and attitudes?

School people and educational psychologists distinguish among concept learning, skill learning, attitude formation, appreciations, and so on. Learning to demonstrate a theorem in geometry is not the same as learning to use the typewriter, and both differ from learning to respect one's elders in general and teachers in particular. Furthermore, pupils differ in their ability to achieve these learnings.

Learning theories are no less variable. According to one theory, learning is brought about by conditioning, that is, by systematic reward of the desired responses and punishment of the unwanted ones. By this method pigeons can be taught complex skills and rats learn to run complicated mazes. Conditioning techniques are successful in teaching a wide variety of skills and attitudes, such as reciting the multiplication table, spelling hundreds of words, and recollecting numerous facts in history and geography.

Do these techniques also explain how one learns number theory? Or learns to understand the theory that underlies the facts symbolized by the periodic table of atomic elements? Or what it means to demonstrate a theorem in geometry? Does learning the *actions and words* that pass for respect toward leaders also produce the *attitudes* of respect? Do they result in learning the principles that justify the attitudes and actions?[1]

The value of learning the arts of reading, reckoning, writing, spelling has rarely been questioned. Like the arts of carpentry, plumbing, and auto mechanics, they connect directly to the common tasks of life. By extension, teaching certain graces in manners, dress, and speech is easily justified in education if they have direct bearing on social or economic status.

Learning That and How

Common to all skill learning is practice on a set of typical situations with (1) a set of rules for identifying the task, (2) selection of the proper rule to be applied, and (3) repetition of these procedures to a high level of dependable performance, sometimes called overlearning. For the

most part, vocational skills are taught through some form of apprenticeship, tutelage by a master of the craft. The outcome is "knowing how," plus familiarity with the appropriate "knowing that." The test for the mastery of these learnings is the ability to perform on demand pretty much what has been practiced during the learning. This type of learning may be called *replicative*.

When some of these vocational skills involved linguistic and numerical symbols and when their manipulation became useful to the population at large, schools were established. Their methods of instruction and the uses of it were not very different from those of the craftsperson, albeit the instruction could not be as highly individualized as it might be in an apprenticeship. At the end of a successful apprenticeship, the artisan would practice and smooth out skills learned during the training. If problematic situations arose in practice that were not encountered in the training, the worker was not responsible for finding a new solution.

Mastering the three Rs, however, does not guarantee good performance in nonschool situations. The reading practiced in school is but a small sample of the materials that might have to be read in life. The same holds for the other two Rs. Some generalization is required to apply these skills to situations that were not practiced under the eye of the teacher. How to solve algebraic equations and how to decide which equation to use in a particular problem differ in their demands on the abstraction potential of the individual. Practice on more or less standardized tasks helps but does not eliminate other cognitive demands of real life. There remains the need to generalize the practiced solutions to unpracticed ones. Complaints against the inefficiency of the schools are of both kinds, namely, that skills have not been developed sufficiently, either at the technical or applicational level. However, the complaints point to somewhat different inadequacies, for which there may be different explanations. Inasmuch as learning precise responses to standard stimuli is supposed to be a matter of conditioning, the only excuse the school has for delinquency in this department is insufficient rigor in reinforcing the desired response positively, by reward, or negatively, by punishment. Hence the complaint that schools are too easy and too easily satisfied by imperfect performance. Inadequacies in application, however, cannot be blamed wholly on failures of conditioning. Generalizing ability is thought to depend on and indeed to be a measure of mental ability, an ability supposed to be beyond the power of the school to alter.

Learning Why

Learning *why* seems to demand something more than conditioning. Gestalt psychologists speak of patterns of perception. Cognitive learning theorists talk of structures of knowledge and information processing. Both direct attention to wholes, the elements of which are related to one another in meaningful ways.[2]

The motions of the earth and stars can be explained by more than one theory; a figure is seen at one time as a jug, at another as a rabbit. Thinking requires theories that deal with *systems* of ideas, with generalizations that cover particulars that are not identical. We learn to *recognize* particulars; we have to *discern* patterns to understand the relations among particulars. Concepts are shorthand summaries of patterns of ideas; for example, the concept of an atom requires understanding of a complex theory about the way matter is constituted. Some agree with Jean Piaget that the child goes through a series of stages that successively increase the capacity for abstraction.

That some learnings involve the discernment of a pattern or design, as the Gestalt psychologists insist, is of prime importance to the role of imagery and imagination in learning. When Wolfgang Köhler[3] described how one of his chimpanzees figured out how to reach a banana placed out of his reach by moving and climbing on an available box in his cage, he "restored insight as a fact in American psychology."[4]

Gestaltists argue that we perceive patterns and that, if a strong, obvious pattern is not already present, *we* pattern the field of perception ourselves. We tend to group lines and shapes so that a whole or sets of wholes are perceived.

Feelingful Knowledge and Knowledgeful Feeling

There is a type of experience that goes beyond or comes before generalizing and systematic thinking. On rare occasions it yields products that profoundly change our ways of thinking and feeling. In their simplest form, these experiences are attitudes, friendly or hostile, toward persons and things. Like skills, they might be explained by conditioning, designed or circumstantial. Often they come into being without training: one encounter with a stinging bee is sometimes sufficient to produce a lifelong fearful attitude toward this insect. But attitudes tend to become complicated—mixed-up reactions of fear and pleasure, a condition of being drawn to

and repulsed by the same object. This complicated response is especially marked in human beings, who *think* about the objects that attract and repel them. In aesthetic experience the feelings blend with ideas to produce images of feeling. This cognitive feeling that is also feelingful cognition constitutes the realm of the aesthetic, that is, of knowledgeful feeling and feelingful knowledge.[5]

Images

Images are sensory patterns. One speaks of visual images—the patterns produced by the eye and brain. Auditory images tell us what an experience sounds like, and similarly, one can speak of olfactory, kinesthetic, and tactile images. Not all sensory experience yields images, however. A pain in the neck or the eye or the arm may not be an image of anything; it may be a localized sensation of pain and nothing more. It may be characterized as strong, intense, sharp, or dull, but to become an image, the pain has to be "like" or "of" something, not *simply* a pain or hurt. To say, "Tom is a pain in the neck" is to form an image of Tom acting *as if* he were staging an attack on the nerves of a person's neck. Smells are usually classified as fragrant, putrid, sweet, and so on. To create images out of sense qualities one must resort to metaphor, to figures of speech. "The fragrance of the morning," for example, is a figure of speech, because mornings are not literally fragrant, albeit the air one breathes in the morning might be. The image is always a substitute for something of which it is alleged to be a likeness. Thus a picture may be the image of a real person, and a picture of someone taking a picture of the person is also an image.

Imagery and Retention

Retention is the most common measure of scholastic achievement. School tests measure the amount of instruction retained, or replicated, in response to questions. In his discussion of the effects of imagery on retention, Allan Paivio states that "imagery is centrally important in facilitating long-term retention, at least for adults."[6] Britta Bull and Merlin Wittrock note that the role of imagery in retention among children is less well understood.

In their own experiment, Bull and Wittrock[7] tried to determine the relative effect on retention of three methods of teaching the definitions of eighteen nouns. The eighteen nouns were select-

ed from a seventh-grade spelling test.[8] Half were high-imagery nouns and half were low-imagery nouns. In each of three classrooms, children were randomly assigned to one of three treatments: (1) self-discovered imagery, (2) given imagery, and (3) verbal definition. Meaningfulness was defined in terms of the mean number of written associations a subject made in thirty seconds.

> The verbal definition group or control group was told to learn each definition by reading the words and writing them down repeatedly during the allotted interval. The "imagery given" group received words, definitions, and illustrations. They were instructed to read the word and definition and then write it down once and then to trace its picture. The "imagery discovery" group was to follow the instruction given the second group but instead of tracing the given illustration were to draw a pictorial representation of the word and its definitions. It was found after due respect to statistical cautions that the retention rate was better when 10-year-old children "discovered and drew idiosyncratic images to represent nouns and their verbal definitions."[9]

Paivio's explanation is that according to neurological and psychological research, the brain stores information in at least two different modes: imaginal and verbal. Thus, imagery allows the learner to elaborate a verbal input into the more concrete imaginal one.

In concluding their article, Bull and Wittrock note that imagery is once more becoming an important subject for study by educational psychologists.

This is not surprising in view of the difference in the abstraction level of verbal and imagic appropriation. Words do not look like the objects they denote, although if they are traced to their etymological origins, the imagic root will become more evident. Thus the word *pantry* in current usage means a small room near or in the kitchen used for the storage of foods and household utensils, but the root meaning of the word, "breadhouse," is more easily translated into images.

Penitentiary in ordinary usage is defined as a place where prisoners are kept. It is one of the abstractions in a system of abstractions that make up the structure of the judicial-penal systems. Yet etymologically, a penitentiary is a place for penitents or sinners on the road to repentance. Sinners and repentance are more concrete notions than judicial and penal systems.

Concreteness can work against the need to generalize. The particularity of the image tends to interfere with abstraction unless—and it is a big *unless*—the image itself conveys a portrait of

human import that is already at a high level of generality. Classic aesthetic theories make precisely this claim for "great" art. [10]

The Bull and Wittrock studies are laudable in confirming empirically what educators have intuitively practiced for ages. Relating words and things by means of pictures is a theory that goes back a long way, certainly as far back as Comenius. It was a protest against the traditional teaching of language, especially of the Latin tongue, through memorization of the definitions of words and the rules for their usage. Comenius goes down in history as a forerunner of the democratic vision of the common school, but in his day he was famous for *Orbis pictus*, a textbook that used pictures to facilitate the learning of Latin vocabulary. [11]

Less attention has been paid, however, to the converse process, namely, the generalizing potential of images, whereby a highly complex structure can be apprehended directly through an image. The idea of holiness, for example, is the theme of numerous works of art and many theological tracts. Who is to say that gazing sensitively at pictures of the Crucifixion or the Madonna will not convey the idea more adequately and perhaps even more accurately? Acres of words are needed to explicate the import of heroism, while one picture, such as the raising of the flag at Iwo Jima, or a song such as the national anthem conveys it immediately.

This is not to denigrate the power of language. It is, after all, our most sophisticated form of communication, the tool subject par excellence. The danger, of course, is to overestimate mechanical literalness as the demands for "functional literacy" are likely to do. The antidote is to take '*rt* as the fourth R, the language of feeling.

IMAGERY AND THE IMAGINATION

This brings us to the peculiar powers of the imagination—the image-making function of the mind. Out of the sensations of the eye, ear, touch, smell, the mind can form patterns of feeling. It can endow inanimate objects with qualities that, strictly speaking, belong only to persons.

How can the imagination accomplish this? We know that the eye can "take a picture," because the eye is something like a camera with a lens and a film (retina) to record the light coming through the lens and pass it on to a particular portion of the brain. Less clear is how the mind processes stimuli of the optic nerve sent to it by the eye, how it discerns similarities and differences among messages, not only those transmitted by the eye but by the ear and the other senses as well.

Is there a supersense that does the comparing and judging? Consider the case of the person who says, "Tom is a pain in the neck." If one does not really feel a pain in the neck, how can he convey a clear meaning by saying what is literally false? If pressed, the speaker might explain this locution somewhat as follows: "Tom's actions, speech, and general demeanor make me uncomfortable. This discomfort is something like that which I experience when I twist my neck muscles—not excruciating perhaps, but a nagging discomfort." Listeners not familiar with English might be puzzled if their own language did not contain this expression, but the chances are pretty fair that they could come up with an analogous locution no less expressive.

Once we have loosened the tie of symbol or sign to that for which it stands, we are free to combine images almost at will. The key to this power is the separability of the image or other symbol from the thing or, more technically, from its ordinary denotation. If, for example, we separate the sky image from its denotation—literally, the atmosphere above the earth, with its clouds, sunshine, and other attributes—we can isolate one of its features—"being very, very high," for example. It then becomes possible to understand a gambler who says, "The sky's the limit." Or more generally, it becomes possible to use language and thought figuratively or metaphorically.

It is but a step, albeit a long and bold one, to ask, "Is what I have imagined more than a figure of speech? Is it perhaps a clue to reality? If not an actuality, then a possibility?" If one can imagine flying through space like a bird, is it possible that one could manufacture wings? If it can be

imagined, what is to prevent one from having a million dollars instead of a thousand? Or dozens of bewitching companions instead of one or none?

It is not difficult to envision the next step, namely, to try to make the imagined possibility actual—in short, to be creative. From this point on, not even the sky is the limit. And it is but a step from what is imagined as possible to the demand that it become actual. And so abstract patterns of perfection—ideals—are born, and possibilities turn into imperatives. "What might be" is converted into "what ought to be." And what ought to be ranges from traffic laws to the Ten Commandments.

This emancipation of the mind from the constraints of actuality is a double-edged sword. The freedom it releases has no inherent limitations, and for that reason the imagination has been revered and feared at the same time.[12] Imagination gives the human mind a freedom to create that seems more than human, the privilege of the gods. For the human being to claim and exercise this freedom would be considered hubris, a challenge to the power of the gods. Perhaps it was this knowledge of good and evil—of what might and ought to be—that was to be kept from Adam and Eve in the innocence of the Garden. History has provided ample reason for this apprehension.

Imagination, being a loose cannon of the mind, unsurprisingly has potentiality for all sorts of good and evil. Imagination has provided more and more rigorous criteria of actuality. Science depends on imagination for the possibility of discovering laws of nature. It took a mighty feat of the imagination for Newton to envision the laws of motion in the fall of an apple, no less for the Founding Fathers to propose that all men are endowed by their Creator with inalienable rights to life, liberty, and the pursuit of happiness. No other animal, so far as we know, entertains such a notion, and not all human animals take it seriously.[13]

Yet imagination can trivialize existence as well as exalt it. It is possible to arrange mirrors so that a single object yields many images—images of images of images. Images on the movie screen can represent events that are images in the minds of the characters. And these doubly imaginary characters can envision themselves playing roles in still another movie. The play within a play within a play within still another play is a literary device with a venerable history. And psychoanalysis is rich in examples of reiterative imagery.

Deconstructivist theories in philosophy and literary criticism argue that all assertion is interpretation. The written text in literature, for example, is said to be no more than an interpreta-

tion by the author that is subject to the interpretation of the reader, which, in turn, has been shaped by cultural forces. The truth (if there be any) requires peeling away the layers of interpretation that have come to be perceived as part of the "real" object. The denial of a foundation that tests interpretation for reality, on the one hand, is a powerful assertion of freedom from constraint of custom, prejudice, and culture; on the other, it condemns the human spirit to an endless alternation between the quest for certainty and the certainty of failing to find it.

From all this it should be evident that there is a "good" imagination and various forms that are less so. Coleridge distinguished imagination from fancy, and others have noted the difference between the reproductive and the productive imagination.[14] In fancy and reproductive imagination, elements are combined more or less freely without the control of a goal or purpose. It is a play of the mind that combines all sorts of ideas in more or less random fashion—a play of images and ideas for the sake of play. By association, one idea or image suggests another and another, but the process never goes beyond rearrangement of what is already in the repertoire of the fancier.

By contrast, the productive imagination produces something new and important. Newton's imaginative activity set off by the fall of the apple or Einstein's cogitations on the nature of time and space represent high points in the powers of the imagination. They are not simply combinations of existing images and ideas but the emergence of a vision that had never existed, or at least had not been hitherto revealed.

Imagination plays a familiar role in daily life and a distinctive one in explaining it. If, as Kant argued, it grounds the *possibility* of knowledge by enabling the mind to organize knowledge, imagination acquires philosophical importance.[15] As for art, being imaginative is virtually equated with artistic creativity or artistic merit.

However, it was not always so construed. It was not until the Romantic period that artistic merit was equated with the creative powers of the imagination. In contrast to Kant, Schelling, and Coleridge, who conceived of imagination as an instrument for acquiring knowledge above that of reason, Spinoza regarded imagination and the fictions it produced as evidence for the need of reason to set it straight.[16]

At this juncture we get into trouble. Is all art imaginative in the Coleridgean sense of being productive, or does what Coleridge dubbed "fancy" also produce art? Should children at home and in school be encouraged to play with ideas, indulge in make-believe so as to help them cul-

tivate the imagination? Is art education simply another way of freeing the imagination from the strictures of fact?

When do images become messages? We are far from knowing what "wisdom of the body" infants bring into the world at birth, but it must be considerable, since they have survived nine months of complicated biological existence. It is not too much to suppose that as the senses become active, they are associated with already existing feelings of pleasure and pain—the intimations of promises and threats.

The rustle of a leaf, the odor of a plant, the texture of bark or soil may be the minimal ingredients of animal and human cognition and evaluation. In this sense we can speak of the image as a signal of human import. The next step is the critical one, namely, the distinction between the signal and its referent. Is the rustle in the woods *really* dangerous or only an image of danger that may or may not turn into hostile teeth and claws? Once this question is raised—implicitly or explicitly—the possibility of cognition is born. The relations of signals, symbols, and signs to their referents and their separability from them are the subject matters of thinking and judging.

Hence, imagination refers not only to sensing of images but also to the construction of images that may truly or falsely claim to be images of actuality. From the beginning, it would seem, sensory stimuli were utilized by the organism as signals of danger or satisfaction, but we do not know how many centuries elapsed before the appearances of things, events, and persons were perceived as clues to their human import—that is, when they became expressive of human concerns and when human beings created appearances to express these concerns.

If this discussion seems to belabor the obvious, then one should consider how far from these beginnings the facile prattle about art has come or perhaps gone; why we have to struggle to reconnect art with cognition and judgment; why the realm of the aesthetic has wandered so far from the fabric of everyday consciousness, language, and practical judgment and has instead lodged in museums and concert halls; why aesthetic education has come to be considered a delightful seasoning of life rather than a certified component of the educated mind.

This more inclusive role of the image can profit from the concept of the allusionary base. *Allusion* is less precise and direct than *reference*, closer to connotation than to denotation. The assessment of liberal or general education depends in large part on why and how the allusionary base is created and how it functions.

THE ALLUSIONARY BASE

The role of imagery in learning is both direct and indirect. The direct form is illustrated by the immediate perception of patterns of sounds, shapes, colors, motions that convey meaning. Indirectly, images influence language, concepts, values, and ideals by association. They form part of the allusionary base.

The allusionary base refers to the conglomerate of concepts, images, and memories available to provide meaning for the reader or listener. For example, it would be reasonable to expect a citizen of the United States to have encountered references to the Bible, the Declaration of Independence, the Constitution, and many characters in American history. Among educated readers one would expect the allusionary store to include some Greek and Roman mythology and major concepts of the physical and biological sciences. When attending to discourse that includes references (explicit or implicit) to these concepts and images, the reader or listener raids the allusionary base for relevant words, facts, and images. If the allusionary base is meager and disorganized, the reader or listener has to let much of what is heard and read go by as just so many words. Reading or listening to a foreign language illustrates the difficulties engendered by gaps in the allusionary base. With the help of a dictionary, one can decipher the meaning of every word in a statement and yet not really understand it. Poetry, especially, depends heavily on the allusionary base to supply appropriate images as the words are read. Accordingly, language instruction without an adequate imagic store often misses the mark. Poetry, drama, and novels require extensive footnotes to explain references to remote times and places—that is, to supply meanings not available from the allusionary base.

The allusionary base may well be the matrix of reading comprehension. After letter and word identification has been mastered, there remains the task of understanding what is read. Strange words can be looked up in the dictionary, but one has to read to use the dictionary, and the dictionary explanation may often be more difficult to construe than the word being defined. For example, a dictionary might define *dictionary* in part as follows: "A work of reference in which the words of a language are listed, usually with their meanings, spelling variants, etymology, pronunciations, and so on."

Does this definition help the genuinely ignorant or innocent reader? Does it help the beginning reader? Clearly not. Using a dictionary requires a high degree of reading comprehension—

more, for example, than sounding out the words or learning the spelling of the word *dictionary*. To make sense out of the dictionary explanation or description, the reader needs a rich allusionary base—a well-stocked store of words and images with which to construe the printed words of the dictionary.[17]

Alasdair MacIntyre makes a similar point in discussing the translatability of different languages into equivalent meanings.

> But the suspicion which I have gradually come to entertain about this type of project is that what can be expected from it is perhaps not so much an adequate semantics for natural languages or a theory of truth in such languages as a series of excellent phrase Books for Travelers. For it is precisely those features of languages mastery of which cannot be acquired from such phrase books which generate untranslatability between languages. . . . What are these features? They include a power to extrapolate from uses of expressions learned in certain types of situations to the making and understanding of new and newly illuminating uses. The availability of this power to the members of a whole linguistic community . . . depends in part upon their shared ability to refer and allude to a particular stock of canonical texts, which define the literary and linguistic tradition which members of that community inhabit.
>
> It is characteristically poets and saga reciters who in such societies make and continually remake these at first oral and then written texts. . . . Concepts are first acquired and understood in terms of poetic images, and the movement of thought from the concreteness and particularity of the imaged to the abstractness of the conceptual never completely leaves that concreteness and particularity behind. Conceptions of courage and of justice, of authority, sovereignty and property, of what understanding is and what failure to understand is, all these will continue to be elaborated from exemplars to be found in the socially recognized canonical texts.[18]

Are there "natural" meanings in sensory states? According to Fred Dretske, there are.

> If a sea snail doesn't get information about the turbulence in the water, if there isn't some state *in* the snail that functions as a natural sign of turbulent water, it risks being dashed to pieces when it swims to the surface to obtain the micro-organisms on which it feeds. . . . If, in other words, an animal's internal sensory states were not rich in information, intrinsic natural

meaning, about the presence of prey, predators, cliffs, obstacles, water and heat, it could not survive. It isn't enough to have internal states of these creatures mean something *to us*, for it to have *symbols* it can manipulate. If these symbols don't somehow register the conditions in their possessor's surroundings, the creature's symbol manipulation capacity is completely worthless. Of what possible significance is it to be able to handle symbols for food, danger, and sexual mates, if the occurrence of these symbols is wholly unrelated to the actual presence of food, danger and sexual mates?[19]

The "natural" meanings as internally sensed to which Dretske and MacIntyre refer are even more directly asserted in Isaiah Berlin's discussion of Giambattista Vico's claim to direct knowledge of our internal states.

When we say that our blood is boiling, this may for us be a conventional metaphor for anger, but for primitive man anger literally resembled the sensation of blood boiling within him; when we speak of the teeth of ploughs, or the mouths of rivers, or the lips of vases, these are dead metaphors or, at best, deliberate artifice intended to produce a certain effect upon the listener or reader. . . . Men sang before they spoke, spoke in verse before they spoke in prose, as is made plain by the study of the kinds of signs and symbols that they used, and the types of use they made of them.[20]

If all this seems obvious or is taken for granted, the perennial push for functional literacy should disabuse us. Functional literacy reduces reading skills to the minimum needed to decipher utility bills and want ads and to write business letters. Advocates of functional literacy may be justified in their insistence on this minimum of reading and writing competence, but that it will automatically expand to enable the reader to deal with other linguistic materials is a vain hope. It will not develop the store of imagery and concepts that renders the printed word meaningful in the "meaningful" sense of the word.

In more technical terms, the allusionary base provides for the connotation of words—written or spoken—and goes beyond denotation, that is, beyond the words' function as names of things. The ability of the pupil to point to a dictionary in response to hearing the word is sufficient for denotative purposes (although in the reference room of a library it may not be). Denotational

definition helps identify the object, but will it yield a meaning for the phrase "He is a walking dictionary"?

The arts deal exclusively in images—visual, tonal, kinesthetic. Some are images of things found in the world around us—houses, flowers, clouds, people. Some images can be perceived as merely denotative, much as a photograph or a diagram might be. But in art the images are expected to be connotative also, images not only of recognizable things but of their human import as well.

Import is the concern of human beings with value, and the value of a thing has to do with its potential for satisfying or frustrating some need, real or imagined. Some visual images are so similar to what they depict that their value is obvious. Pictures of delectable foods, expensive automobiles, and jewelry are directly perceived as desirable. But for every obvious and direct connotation of value—positive or negative—there are numerous unnamed value intimations that may be conveyed directly by a painting, poem, or piece of music.

There is virtually no limit to the variations of feeling portrayed in the arts. A thousand variants of love, jealousy, and tenderness are to be found in poetry and music—and similarly with the other emotions, many of which have no names. Their range is enormous, but our perception of them is often meager, perhaps because formal schooling neglected the skills of aesthetic perception.

What fairy tales, comics, and popular art begin, formal schooling needs to develop and organize—if the purpose of formal schooling is the educated mind. For, as in other areas of experience, the educated mind is distinguished by the range of experience it can accommodate, on the one hand, and by the intensity of that experience, on the other. This is true in every value domain. Economic values, for example, cover a broad range of feelings about worldly goods (or evils) and generate no less broad a range of intensity of these feelings. The same may be said about health, recreational, associational, civic, intellectual, moral, religious, and aesthetic values.

For each value domain there is a science or a discipline that brings intellectual order to it. Formal schooling is expected to supply the concepts by which this order is achieved. Analogously, the range of feeling in every domain becomes "educated" by commerce with what the scholars, at a given time, judge to be the exemplars of fine, or high, art. These terms raise the hackles of

those who bridle at the elitist connotations of "fine" or "high" art. But all these terms need mean is that when art has become the target of scholarship and connoisseurship, it becomes "serious." Folk art appeals spontaneously to the common folk, but if the scholars get after its history, structure, variations, and criteria, it enters the domain of serious art.

Educationally, serious art, like serious science or history, is to be contrasted with the untutored variety of lore, myth, and—one might add—"common" sense in which they had their beginnings.

The allusionary base, therefore, is the generic term for the stock of meanings *with* which we think and feel. It functions in the learning of languages—scientific, technical, evaluational—of skills, concepts, and attitudes.

LANGUAGE AND THE ALLUSIONARY BASE

The most striking difference that one study found between the language of educated and noneducated groups lay in the fact that the vulgar English group seemed essentially poverty stricken.

> It uses less of the resources of the language, and a few forms are used very frequently. Get, for example, in its many senses appears in both Standard and the Vulgar English materials, but is employed ten times as frequently in the Vulgar English letters as in those of Standard English. . . . In vocabulary and in grammar the mark of the language of the uneducated is its poverty. The user of Vulgar English seems less sensitive in his impressions, less keen in his realizations, and more incomplete in his representations. It would seem a sound inference from the results of our study that perhaps the major emphasis in a program of language study that is to be effective should be in providing a language experience that is directed toward acquaintance with and practice in the rich and varied resources of the language.[21]

Another consequence of linguistic poverty may be a lack of associative resources and therefore a diminished power to generate connotations in response to linguistic signals. The reading of literature in general and poetry in particular would be directly affected by such linguistic poverty. The cognitive uses of language are also affected by the volume of what J. F. Herbart called "the apperceptive mass."[22] Both art and science depend on the imaginative powers of the mind, and although language is unable to label all that the imagination can conjure up, it is by far the best catalogue of experience we have. Poverty of linguistic resources may betoken poverty of thought and feeling as well.

As to the influence of literature study, how many of us respond to material about Great Britain in terms of the literature we studied in school? Had my first view of the Lake District or the Forum in Rome not conformed to images conveyed by school studies, I probably would have rejected the realities rather than the images. The way in which the poet, novelist, artist, composer perceived the time in which they lived and the way they personified the values of the time in images are important resources for the educated response to social problems.

How much visual imagery, for example, is needed for perceiving the import of William Butler

Yeats' lines in "Sailing to Byzantium"

> *An aged man is but a paltry thing,*
> *A tattered coat upon a stick, unless*
> *Soul clap its hands and sing, and louder sing*
> *For every tatter in its mortal dress,*[23]

or the lines of Gerard Manley Hopkins' "Pied Beauty"

> *Glory be to God for dappled things—*
> *For skies of couple-colour as a brindled cow.*

I have experimented with classes of undergraduates on the imagery evoked by words of Latin origin. Although some students who had studied Latin did not respond with the image "breathing across" for the word *transpire* or "breathing with" for *conspire*, I never encountered such images in students who were innocent of Latin studies—all of which suggests that when researchers announced that the study of Latin did not contribute as much to vocabulary growth as did the direct study of vocabulary and that the public schools no longer required Latin study, they should also have deleted the study of Milton's poems. Similar deletions might be in order for literary works that have their origin in the Bible or Greek and Latin mythology.

Although imagery is a prime factor in the associative uses of schooling, and although art is among the major sources of such imagery, it is not the only one. Suppose we come across the term *Elizabethan drama*. This phrase is a placeholder for a host of associations: Queen Elizabeth, Henry VIII, a ruffed collar, Mary, Queen of Scots, Shakespeare, knights, battles, the Tower of London. Henry VIII is a veritable freight train of associations: historic, erotic, religious, and political.

It is more or less taken for granted that the poetic uses of language depend heavily on imagery for their effect. "This is the forest primeval" and "On the trail of the lonesome pine" are clearly highly figurative locutions and call upon the imagination to construe them properly. There is a type of prose, however, that also relies heavily on metaphor and other figures of speech. Slang, the poetry of adolescents, and oratory, the poetry of politicians, also depend on the aesthetic

uses of language. The assertion that Senator So-and-so or Commissioner So-and-so is a "wimp" may be perceived in a number of images. A halting delivery, the fall of the voice toward the end of a phrase, a limp posture, hesitant gestures—all are visual, kinesthetic, and auditory images of weakness. It takes a great deal of factual evidence to the contrary to convince the electorate that appearances are deceiving.

As to oratory, its dependence on aesthetic images has been notorious from Demosthenes on. Cicero's *De oratore* is still a workable handbook for the education of orators and lawyers. Among the requirements for the teaching of rhetoric in the days of Cicero and Quintilian was the composing of imaginary speeches that might have been given by some historical or mythological figures. Retelling fables and describing objects and events vividly were also among the prescribed exercises. In short, one key to efficient oratory was a store of images, concepts, and sensorimotor affective patterns that could serve as standards for the learner.[24]

In his State of the Union message on February 5, 1986, President Ronald Reagan utilized at least five dozen figures of speech to convey how he believed the citizens ought to feel about the past, present, and future of the nation. Here are just a few examples: "Go forward, America, reach for the stars"; "a land of broken dreams"; "a lumbering giant"; "slamming shut the doors of opportunity"; "this nation under God"; "a mighty river of good works"; "freedom is on the march"; "but we cannot stop at foothills when Everest beckons"; "I'll take the heat."

This list is not cited as a reason for teaching poetry to develop literacy—especially what is called functional literacy. However, it does emphasize the part played by imagery in the comprehension of language, as even a cursory analysis of the figures of speech listed above will demonstrate. What, for example, is needed to construe "but we cannot stop at foothills when Everest beckons"? First is the notion of a foothill. What image is this word intended to convey? A hill shaped like a foot? What sense would that make of the sentence? Until readers translate the term into images of a fairly low hill or a series of hills that are often encountered as one approaches a range of tall mountains, the sense of the metaphor eludes them. "Everest" requires the knowledge that Mount Everest is a very high mountain and, further, that it has served as a symbol for high aspiration to mountain climbers all over the world, as well as knowledge that exciting races to reach its summit occurred in the not-too-distant past, which, of course, were attended by copious publicity. The key to the sentiment of the metaphor lies in

the words "we cannot stop at" and "beckons." The two phrases encapsulate complicated psychological states of mind. The first is the urge to stop when one tires of great effort against ostensibly insurmountable obstacles; the second is the response to a goal so enticing that one is drawn powerfully to undertake the seemingly impossible task.

Or consider the phrase "freedom is on the march." President Reagan undoubtedly took for granted that his audience would have no trouble furnishing the imagery for this message. Yet it requires considerable conceptual and imaginative resources. Freedom is an abstract quality denoting both a physical and moral state. A person in prison is physically and socially unfree. But incarcerated persons may still be morally free, if they can exercise the will to act. Some are physically free to do many things that their moral precepts prevent from being willed. It is difficult to guess which type of freedom the president was invoking, but he probably had little doubt that the phrase would elicit the appropriate image of the feeling he was seeking to inspire.

The next image to construe is that freedom is "on the march." Here an abstract quality becomes a marching figure, perhaps a soldier or a regiment of soldiers. However, abstract qualities are, literally speaking, unable to move, let alone march anywhere. And if this difficulty is overcome, then where is freedom marching? Nevertheless, listeners for the most part had no difficulty conjuring up the appropriate images. Marching was a kind of regulated motion toward a goal; the image of people marching around in circles probably would not arise. So the image of freedom setting out bravely for a goal, presumably a noble one, is contributed by the listener. The highly complex process whereby the words "freedom is on the march" are turned into an image that arouses the feeling of wanting to join the march toward highly desirable goals is an exercise of the imagination.

The mechanism on which figurative language depends is the selection by the listener of images, words, and feelings from the associative store. With effort and ingenuity, we might trace the ingression of these words and images into a person's associative resources. A better way of getting at the associative store is to see whether a non-English-speaking person could come up with the needed image by translating "freedom is on the march" into his or her own tongue. A Frenchman, for example, might start humming "Marchons, marchons," and so on, and the images and feelings associated with the "Marseillaise" might well up in him. Whether a Turkish

man would respond with similar images is not so obvious; he might construe freedom in a way that President Reagan did not have in mind.

"I'll take the heat," a bit of slang, is an image of a different sort. To a foreigner, it might be puzzling even after a dictionary defined each word in the sentence. Why would the president promise to accept heat? Was he cold? And from what boiler would the heat come? Young children might be equally puzzled by this phrase, even as they might be on hearing, "If you can't take the heat, stay out of the kitchen." A similar bit of familiar slang is "The buck stops here." How does a male deer that stops at a given place connote a heroic stance? If *buck* is not a male deer, then what sort of thing is it that is in motion but stops here? How would one explain this to a young child or a foreigner?

Linguistically, these moves take time to describe and explain. In experience the figure of speech works almost instantaneously, *if* the listener or reader has the requisite imagic-linguistic resources. How does one acquire them? Clearly not by consulting the dictionary for an accurate rendering of word meanings. Rather, these resources are built up out of a mélange of information about mountain ranges and their foothills, Mount Everest, and the political credo of President Reagan. Yet the meanings of the terms do matter. They depend on the extent and accuracy of vocabulary, which presumably is growing as one goes through school. A key ingredient of that schooling is reading material that invokes imagery and tests it. Our best source for this is art or the arts, for they live by the metaphors of imagery. "As quiet as a mouse" does pretty well, as does "as strong as a bull," for ordinary exclamations, but "quietness" has likeness to innumerable states of consciousness, as does "strength" and any other emotionally charged term in our repertoire.

IMAGERY AND CONCEPT LEARNING

Learning language and mastering concepts are so closely related that much of what has been noted with respect to the former will be relevant to the latter. Nouns denote classes or clusters of things that share a number of similar properties. The name of a class of things is a concept. Language enables us to refer to the generic and differential properties of classes of objects. This makes abstract thinking possible.

Perhaps the most famous dictum on the relation of concepts to sensory experience is Kant's "concepts without percepts are empty; percepts without concepts are blind."[25] Logic without perceptual content is empty. Sensory experience is a meaningless flow without the organizing effect of concepts. Those who hold that sensory experiences carry "natural" meanings would challenge the second conclusion. Those who argue for the possibility of imageless thought would challenge the first. They claim to do logic and mathematics without sensory perception of any sort. More difficult to understand is the claim that one can experience the "beauty" of a theory or the "elegance" of a mathematical proof without perceiving some sensory properties. What is *elegant* supposed to mean when used to characterize a theory, if not some perceptual or sensory image of graceful form?

An equation is an assertion of the equality of two sets of symbols joined by the symbol $=$, but in what is equality grounded save the aesthetic concept of balance? One could argue that the left-hand side of the equation is the "name" of the right-hand side, and vice versa. But such a locution does away with the concept of the "elegance" of a mathematical proof.

Educationally, it is a truism that to teach concepts without perceptible examples will be hard going even for learners with good intellects. The more abstract the subject, the more perceptual examples, designs, and illustrations are needed for the production of insight. An example is the difficulty many of us have in understanding weightlessness in space. The *fact* is by now familiar, because we have been shown *pictures* of bodies floating around, contrary to our expectations of how unsupported bodies should behave. But do we understand it? And why is it so difficult to understand? In part, because we find it difficult to form images that displace that of a force called gravity pulling all objects toward the earth. Gravity is a pull, and without this pull, what would happen to the ingredients of the universe? Is there a pull that keeps the planets and galaxies from flying apart? And what keeps atoms and molecules together in physical objects?

These imagic questions lie at the root of arcane theories that purport to explain these phenomena.

Some technological developments stagger our imagic resources altogether. When told that supercomputers can perform millions of calculations a second, we may believe it and even understand the principles that make it believable, but can we envisage an image expressive of it?

J. P. Dougherty states that

natural science is so permeated with metaphor that its employment goes almost unnoticed. . . . In physics we speak of light *waves*, talk about heat as *fluid*, gases as if they consisted of plastic *particles*, electricity as a *current*, *drops* of electricity, *anti-matter*, *right-handed* and *left-handed* spin on a K meson. . . . In spite of the widespread employment of metaphor in the sciences, one encounters few theories of their function. Theories of analogy first came into being in an attempt to understand how metaphysics could speak of things divine and not slip into agnosticism or anthropomorphisms.[26]

For J. H. Pestalozzi, "the highest principle of instruction was the recognition of sense impressions as the absolute foundations of all knowledge."[27]

Antedating Pestalozzi considerably, Comenius was shrewd enough psychologically to argue that "the sense of hearing should always be conjoined with that of sight, and the tongue should be trained in combination with the hand. The subjects that are taught should not merely be taught orally, and thus appeal to the ear alone, but should be pictorially illustrated and thus develop the imagination by the help of the eye."[28]

For F. W. Froebel, the originator of the modern kindergarten, the Pestalozzian object lesson was not only a focus for perceptual study of sense qualia, number, and shape. The object was selected for study because it had a formal quality that somehow suggested the Divine Unity. The cube, with its regular angularity, and the ball, with its regular curvature, were symbolic of the way nature develops by opposites. Kindergarten activities were endowed with properties that would lead the child to identify with the Divine Spirit and social unity. It required a mystical imagination of no mean order to think of the cube and the ball as "gifts" of the Divine Spirit and to say that play is the highest phase of child development.

No account of Froebel's method would be complete without mention of the famous circle.

The first exercise of the day required children and their teacher to gather in the circle to pray or play together. The circle, the "perfect figure," having no beginning or end, symbolized continuity and regularity—characteristics of the ideal society.[29]

It is perhaps an exaggeration to think of the world as a work of art and the Divine Being as a superartist, and yet it is not implausible to attribute such a notion to Froebel, the early Froebelians, and other educators of the Hegelian persuasion. For many of them, internalizing these cosmic attributes of Being with the help of instruction was the definition of education. This notion or some form of it continues to be the claim of those who want the schools to make art a part of the required general education curriculum. Idealistic aesthetic theory sooner or later asserts the belief in the revelatory and redemptive power of art, especially "great" art.

Whether or not one takes such a theory literally, it remains clear that without images of human import—ones, that is, of concern to human beings—education limps in the development of literacy and the study of most academic disciplines. Indeed, it takes self-discipline of a high order to crystallize and discard these portraits of human feeling and concern oneself simply, wholly, and purely with the logical properties of language. Linguistic purity itself may be regarded as an aesthetic image of the search for pure rationality in the universe.

IMAGERY AND PROBLEM SOLVING

Problem solving combines percepts and concepts, particulars and universals, so it would seem that having acquired a repertory of both, one would also have learned to solve problems. However, combining them involves factors that go beyond percepts and concepts.

Consider a homely sample of problem solving. Following the paradigm that John Dewey made familiar to school people in *How We Think*, how does one deal with an automobile stalling in the midst of a spin in the country?[30] The first stage, Dewey suggests, is a "felt difficulty." The situation has suddenly become unclear, troublesome, puzzling—a predicament. The next step is to convert the predicament into a problem, for contrary to common usage, the two terms are not equivalent. A problem is a difficulty or predicament trussed up for theoretical analysis and possible surgery. To begin this trussing, it is necessary to tap one's knowledge of internal combustion engines. If an engine "dies," it must be caused by: a, b, c . . . n (lack of fuel, overheating, failure in the ignition system, the lubrication system, the electrical system, etc.). To a total ignoramus in such matters, these possibilities would not occur.

Our motorist, however, is no innocent about automobiles and selects for the first hypothesis (educated guess) that the gas tank is empty. If the gasoline gauge confirms this, the problem may have been identified. But suppose the fuel gauge registers one-half—does this eliminate the hypothesis? Not necessarily, because the gauge may not be working properly. A quick calculation of the time since the last purchase of gasoline and the mileage driven (utilizing schooling in arithmetic) provides another clue, which may or may not be definitive. A more promising hypothesis would be, "If the gas tank is empty, a stick or wire pushed to the bottom of the tank will emerge dry." The motorist's conceptual store has been raided for these beliefs; a motorist wholly ignorant of these humble facts would not be ready to formulate a hypothesis in their terms.

The next stage is to test the hypothesis by looking for the predicted results—the stick or wire is dry or not. If dry, that takes care of the matter enough to head for a gas station; if wet, exploration of other hypotheses will have to be formulated until predicted consequences can be verified by sense perception. Every step in the problem-solving process consists of this interplay between concept and percept, between generalization and fact. Imagery is involved at every step: the stopping of the car is perceived and recognized as an unexpected and unwanted situa-

tion. The lack-of-gasoline hypothesis is not wholly abstract—a visual sketch of an empty tank probably accompanies the thought.

At each stage of the process imagination suggests patterns of behavior that could be entitled "If I do this, this will happen." When such imaginative versions of the predicament are not available, the ability to project hypotheses is seriously impaired. For example, the workings of the electrical, lubrication, cooling, and transmission systems are not readily pictured by the ordinary motorist. If the mechanic hypothesizes that one of these is to blame, the diagnosis has to be taken on faith. This explains why so many avid users of computers find difficulty in understanding the explanations offered to them by the technician.

A more elaborate analysis of problem solving is found in Robert H. Ennis' conception of critical thinking.[31] Ennis lists the following dispositions involved in critical thinking:

To seek a clear statement of the thesis or question
To seek reasons
To try to be well informed
To use credible sources and mention them
To take into account the total situation
To try to remain relevant to the main point
To keep in mind the original or basic concept
To be open-minded—looking at things from others' points of view
To seek as much precision as the subject permits
To deal in an orderly manner with the parts of a complex whole
To be sensitive to others . . . without which critical thinking often comes to naught.

Which of the dispositions listed above require imagery? "To take into account the total situation" certainly does. How does one take account of a total situation except by organizing its constituent parts in a unified whole? In any practical circumstance—that is, one not composed entirely of logical symbols (the stalled automobile, for example)—the total situation requires a set of images that picture the interaction of the constituent elements, an image of their cause-effect relations. An aborigine unspoiled by a motor car civilization would hardly be expected to have images of this sort.

"To be open-minded—looking at things from others' points of view" also requires a sophisticated imagic store. It also calls for "imagining" how the problem is perceived by others, that is, trying to arrive at the images others are entertaining. Similar considerations apply to "to deal in an orderly manner with the parts of a complex whole" and "to be sensitive to others . . . without which critical thinking often comes to naught."

The notion that critical thinking can be reduced to purely logical operations relies on "picturing" the problem as a logical formula couched in highly abstract, narrowly defined symbols. But this formulation only comes after the existential components of the situation have been identified and connected in a schema of images.

Dewey stressed learning by doing, but the doing was to be problem solving rather than repetition of an assigned task. Doing, for Dewey, was a kind of thinking, and thinking that amounted to anything educationally was a kind of doing—changing an unclear predicament to a line of action by means of hypothesis, prediction of results, and their testing. William H. Kilpatrick's project method was designed to help teachers translate the theory into classroom practice, and whatever one may think of it as the paradigm for all schooling, it is difficult to argue with its relevance for schooling.[32] For this reason a problem-solving strand is needed in the curriculum, not so much to teach concepts and skills but, rather, to test them.

The concreteness of the problem-solving or project method can easily degenerate into an overemphasis on manipulating tangible objects rather than dealing with words and ideas. *How-to* thus takes the place of *how-to because* and renders it unnecessary to utilize the conceptual-theoretical resources of the learner or group of learners.

Personality Problems

We are often told by counselors that subjects carry distorted images of who they are, what they want to be, what they are expected to be. This image distortion may be both a symptom and a diagnosis, as the ample literature on the subject will readily indicate. Even the daily newspaper has one or more columns designed to straighten out readers' images of themselves and others. This sort of analysis is now one of the psychological "products" marketed in various media.

All of which reminds us that analysis of aesthetic personality problems (or predicaments) may

not be altogether irrelevant. How one looks and how one would like to look take up considerable time in adjustment problems, especially with adolescents.

Whether the problem is one of school, parental, or occupational adjustment, it embodies an aesthetic factor, a knowledge factor, a skill factor, and a value factor. The aesthetic factor has to do with the image the individual has of him- or herself or thinks others have, the image one would like to create, the skill of bringing it about, and the justification of the whole business.

The image problem may be regarded as one of creating an appearance that conveys import of a desirable sort. That may mean anything from a figure that is fashionable to the qualities of personality that are esteemed by one's co-workers, the opposite sex, and employers. The making of images that present what D. W. Gotshalk called "an appearance interesting to perceive" is the work of the artist.[33] To make one's own image interesting is an art that goes beyond the cosmetic industry. It means producing an appearance "interesting to perceive" because it gives vividness, form, and expressiveness to one's body, voice, clothing, and general demeanor—a work of art, so to speak.

Problem-solving Uses of Schooling

In the first step of problem solving, cognitive and evaluative resources function as maps. They also function when we identify, formulate, and appraise the live issues in the problem situation. Much school learning is used associatively as a source of suggestions, reminders, and just plain hunches. Some is used replicatively in the form of recollected facts and rehearsed skills.

Concepts are used to interpret, analyze, and understand problems, and it is the business of general education to provide them. Logical operations are used applicatively for all types of systematic thinking.[34]

Problem solving has been regarded as the best test of formal schooling. The ability of the citizen to apply school learnings to felt difficulties in all phases of living, therefore, is a criterion for all phases of schooling: curriculum, pedagogy, and evaluation.

The role of thinking in problem solving is too familiar to require extended discussion in an essay concentrating on the role of imagery in learning. But in modern life the role of imagery may also be crucial to problem solving. The domination of so many aspects of living by highly complicated technologies is perhaps the major "villain" in the piece. A cart drawn by a horse or

mule that is mired in the mud presents a problem the features of which are clearly evident. All the factors are visible; the knowledge of how mud behaves is not arcane. The principles involved are part of common knowledge—that is, mud is a semifluid substance; objects heavier than mud will sink into it. The image is familiar and clear, and so is the principle. A scientific understanding of fluid mechanics is unnecessary to construe the predicament. No less familiar are the standard remedies: get another mule to help pull the cart out of the mud; place boards under the wheels to improve traction; apply the whip to the mule to elicit greater pulling force, and so on.

Contrast this imagery with that available for the predicaments of motorists, many of whom have only vague notions of the workings of an automobile engine or of electronic communication. Beyond the need for fuel, operation of the vehicle depends on levers, buttons, and knobs, the articulation of which to gears, cylinders, spark plugs, and brakes is imagically a blur of mystery shrouded in a mist of malevolence, an invisible spirit out to do one in.

The unsurprising response is not problem solving but trial and error—pushing this button, jerking this lever, lifting the hood and staring. The situation is encountered in virtually every phase of modern life—cooking, repairing household gadgets, maintaining light, heat, ventilation, and communication devices, let alone predicaments that arise in the management of our bodies and minds.

The difficulties are of two sorts: one is the need for understanding the principles upon which the mechanism depends; the other, the need for forming images that portray design, the formal organization of the parts of the mechanism. For example, those who have mastered the concept of matter consisting of molecules made up of elements listed in the periodic table now have to add "pictures" of atoms that are themselves constituted of positive and negative forces, protons, electrons, neutrons, and so on. How many "educated" citizens can "picture" the structure of viruses, benign and hostile cells, and the mechanics of DNA research? Even those who understand the terminology and can define the concepts may have difficulty "picturing" what is alleged to be taking place. The current terror regarding acquired immune deficiency syndrome (AIDS) is a vivid example of image frustration. Images revealed by high-powered microscopes and complicated electronic scanners are bewildering to the lay public, even those who have the benefit of college degrees.

Hence the paradox that the more advanced the technology, the more dependent the citizen—even the educated one—becomes on technologists. The technology that frees in one direction enslaves in another. One of the by-products of this paradox is an effort by the artist to create images of it. Much of Modern and Postmodern art is an attempt to picture in terms of feeling the predicaments of modern human beings—to picture that which seems to defy depiction. "The computer is down" is the modern equivalent of "the devil is at work again." It is not surprising that for some artists technology and demonology share some of the same imagery.

Science fiction furnishes examples of efforts to help the understanding through familiar images embodying mysterious forces that operate in the world. Good and evil spirits are personified, and the difficulties of humanoids are pictured as battles or struggles between good and evil forces.

Problem solving, therefore, as a pedagogical desideratum is an aesthetic "problem" as well as a thinking one. The hypothetico-deductive design for problem solving formulated in Dewey's complete act of thought (CAT) breaks down if at each step the entities about which thinking is to take place are difficult to picture.[35]

As a result, even fairly simple predicaments in a community defy the efforts at collective reasoning on which the democratic theology depends for solutions. There was a time when ordinary citizens could gather in one hall, deliberate on their difficulties, and discuss hypotheses that could be tested for efficacy. Today such situations are rare. Consultants have to be hired, technological experts marshaled, governmental agencies involved, bond issues floated, commissions appointed—all of which culminates in a vote by the public based on little more than sentiments that have almost nothing to do with rational problem solving.

IMAGES AND VALUE EDUCATION

Values are standards, benchmarks against which choices are measured. Each value domain has such standards. In the economic domain the yardstick is productivity or the rewards of productivity; in health it is the efficiency of the body; in the intellectual realm it is the rigor of inquiry; in the religious domain it is faith and obedience to the commandments of the church or its equivalent; in the aesthetic realm, as in many others, the criteria are subject to variations in aesthetic theory. This oversimplifies the situation, however, because each value domain is related to every other, and the internal standards may be affected by the external ones.

Each domain can be, on occasion, the dominant one, especially when it is seriously threatened. When life is in danger, all other values are held in abeyance; and when honor is at stake, some feel that even life must be sacrificed.

When values are in conflict, rational creatures turn to ethics, which aims to formulate universal principles of right action. The greatest good of the greatest number, for example, is the maxim of utilitarian ethics. Good and right are defined as pleasure or freedom from pain, and each act is to be judged by the hedonic calculus, namely, the balance of pleasure over pain that the proposed action would produce.

There is no lack of literature on values, ranging from abstruse discourses on ethics and value theory to exhortations for the restoration of family values, democratic values, economic values, et cetera, et cetera. In common usage *good* is what gives pleasure or satisfaction and *evil* is what impairs pleasure or satisfaction. Through the imagination, the straightforward satisfactions of food, shelter, and sex are transformed, for example, into cuisines too numerous to list and appurtenances of dining that combine nourishment with diverse forms of social intercourse and status. As for sex and shelter, the transformations triggered by the human imagination are too obvious and numerous to catalogue.

More mysterious but no less potent are the images of ideals to which the term *values* commonly refers. Ideals are images of perfection translated into prescriptions for action. Value can be thought of as qualitatively intrinsic, that is, as subjectively experienced, or as extrinsic, as objectively manifested in action.

What role has the image, the aesthetic experience, in learning these norms? Conditioning has to be taken into account, especially in the early years. But throughout life in every value

domain, the image of the right act or attitude (or the wrong one) is the touchstone for learning. Fairy tales are replete with value judgments personified in images of good and bad fairies, good and bad animals, people, and so on. The behaviors of these imaginary figures are the early scenarios for judgments of good or bad, for what is to be punished and what rewarded.

In later life, heroes and villains of sports, adventure, business, the professions are delineated, celebrated, or denounced in fact and fiction. These images are the controlling factors in learning the mores and morals of the culture. While philosophers argue about what makes an action right or wrong and why, parents and movies confront young and old with models of virtue and vice. Here, as in all exemplars, the model accentuates certain features and plays down individual idiosyncrasies so that the image loses ambiguity. Abe Lincoln's image in story and sculpture clears away the actual mixture of good, bad, and indifferent in his life, leaving the central image highly clarified.

Value education has always relied on exemplars. Truth, justice, heroism, courage, loyalty, sincerity, benevolence, compassion, and their opposites make their impact initially through exemplification in some person or action so vivid and communicative that it becomes a model for emulation. Drama, literature, and the other arts collaborate to portray these values. Parents begin the process by shaping conduct in particular situations and hope they will be generalized. But as parents soon discover, the models exhibited by peers and the media are more potent than exhortations to virtue.

We expect from the school some kind of evaluational framework that will orient children toward action, just as the cognitive framework orients them to understanding. Value experience has attitudinal and justifying components. The first influences what one likes; the second tries to give reasons for liking it. The attitudinal component is being formed from the day of birth. By the time children enter school they are already equipped with a repertory of attitudes. About the origin and consequences of their attitudes the children may be ignorant, but of their strength they are fully aware. Strong dislikes of foods and people are not dislodged by the admonitions of parents and teachers or by arguments.

Ordinary people's likings and aversions are shaped by experiences of pain and pleasure and the approval rules of their reference groups. This sort of approval-disapproval mechanism requires no formal tuition. The reference group supplies the norms for speech, dress, and gen-

eral deportment. The price of comfortable membership in the reference group is acquiescence to its stereotypes.

Value education in the school receives cues from its patrons. Public schools receive cues from a variety of political and ideological patrons—the taxpayers. If their pressures are diverse and incompatible with one another, the prudent teacher leaves value instruction alone.

It is tempting to answer the question of curriculum criteria politically, that is, by the wishes of the electorate. And in a democratic society this is the will of the people. Whether a community wants to spend its money on teaching chemistry or ancient history is a political question properly decided by voting. What is good chemistry is not a political issue. For that we must consult the canons of the particular discipline, as determined by the guild of scholars working in that discipline. Experts may not agree in their judgments, but they do agree on what it takes to qualify to make the judgment—scholarship. Their agreements and disagreements constitute the subject matter of scholarship. Just as the school is expected to bring the experts' thoughts to bear on the pupils' inexpert knowledge, so it is reasonable to expect the school to bring the experts' values to bear upon the pupils' rudimentary tastes.

Thus arises the body of "great" works that experts in the several disciplines have chosen to exemplify the spirit of an age, its great triumphs and defeats. They have integrated and vividly expressed the mood and character of the successive epochs in history.

These exemplars are often dubbed "classics," not only for the prestige they enjoy but also for their role as models. The Parthenon is a classic not just because it conforms to certain principles of architectural quality but because, to a large extent, the principles were derived from it. Classics do not always represent the taste of the general public. That is why any curriculum based on the classics is open to the charge of elitism. Yet it is a kind of elitism entry to which is not barred by race, creed, color, or economic status. Such bars, when they exist, are not erected by scholarship but rather by those who limit access to scholarship.

the day. These are appropriated by participation in the culture rather than by formal instruction. The educated mind, therefore, is not a necessity but a luxury that only a rich society can afford. It requires enough leisure to build and use the imagic-ideational store. Most societies cannot afford such luxury for more than a small class. This country is caught between the ideals of excellence and equality. How to have excellence without snobs and equality without slobs is the perennial problem of an enlightened democracy.

AESTHETIC EDUCATION

If images are as influential in learning as this essay claims, their place in the school curriculum is justified. Whether or not images function in the various types of learning depends on the availability of methods and materials of instruction suitable to the several grades (K–12).

It is beyond the scope of this essay to do justice to all the methodological and curriculum problems such a program involves. One aspect of methodology, however, demands special attention because it elicits strong disagreement among arts educators. Briefly, if imagery affects life and learning to the extent this essay claims, then the skills of perceiving aesthetic images should be a major focus of instruction in the elementary grades in conjunction with performance skills. The reasons for this are (1) proper aesthetic perception, unlike the ordinary variety, has to be especially attentive to the sensory content of the image and (2) the skills of perception can be taught to all normally educable pupils by classroom teachers after a relatively short training period. Given the skills of perception, the historical and critical materials (especially by way of exemplars) can be introduced and amplified at appropriate times.

The question is raised: Is aesthetic perception aesthetic education? And how does it relate to aesthetics? Aesthetic perception is comparable to reading a text where the text is an image or a set of images. It construes these images through what Susanne Langer called "presentational" symbols, rather than through the "discursive" symbols of written language.[40] Aesthetic literacy begins with learning to perceive the sensory, formal, and expressive properties of aesthetic images—that is, those that convey human import.

The skills of aesthetic perception may be summarized as follows:

1. Perceiving the vividness and intensity of the *sensory* properties in the work. These features convey the affective qualities of the object by means of colors, gestures, shapes, textures, and so on.

2. Perceiving the *formal* qualities of the object, its design or composition, the arrangements that provide unity in variety through balance, repetition, rhythm, contrast, and so on.[41]

3. Becoming familiar with the *technical* merits of the object, the skill with which it has been carried out.

4. Perceiving the *expressive* significance of the object, its import or message as aesthetically expressed.

There is no mystery about teaching these skills of aesthetic impression, nor is there in devising tests to assess progress in sensitivity in the perception of these properties. Experience in the Getty Institute for Discipline-based Art Education and in Project Heart in Decatur and Champaign, Illinois, can supply evidence for these claims. Furthermore, there is reason to believe that elementary classroom teachers, given a relatively short period of in-service instruction, can master what has been called "aesthetic scanning" and teach it to their pupils (see Appendix). The basic ground rule for these exercises is that pupils be ready to point to something in the object by virtue of which they are willing to assert that it has this or that property or characteristic. What could be more behavioral? There is also nothing to prevent the teacher from having the pupils make their own aesthetic objects to serve as targets for perception. In this way performance training and perception training coalesce. The performer and the maker use perception from moment to moment to test whether the effects they desire are being achieved.

For example, the distinction between sensory and formal properties can be brought out more clearly if we vary one dimension at a time. We can arrange six spots of red in a number of ways, or we can take any one of the patterns and give it a variety of colors or color combinations. Melodies can be held constant while rhythms are changed; rhythms can be held constant while the orchestration is varied. Sometimes works of art can be selected to bring out these distinctions. The plethora of collections of art reproductions now available in the various media makes the task of selecting materials for the study of the various dimensions of the aesthetic experience far easier than it used to be.

The teaching situation changes when we come to the expressive dimension of aesthetic properties. We can still use the perceptual approach, but we can no longer say with confidence just what it is that is to be perceived. Colors and shapes are fairly public objects, and given normal sense organs, there is little difficulty in getting agreement on whether a given area of color is red, green, or violet. The same, of course, is true in the fields of sounds and gestures. But suppose that a seascape is said to depict an angry sea or a melody is said to be cheerful and spritely or a poem melancholy. To what in the aesthetic object do we direct the attention of the observers as evidence for our characterization?

It makes sense to answer that the image as a whole provides that evidence, but sensory and formal properties may also be expressive. Colors and sounds and shapes can be expressive. They can be bright and sharp, serene or agitated. The way unity is achieved depends on aesthetic responses to formal properties. The criteria and language enumerated in the scanning chart (see Appendix) can be applied to the sensory and formal properties of the work as well as to the work as a whole.

And we can be true to the principle of phenomenological objectivity—namely, that whatever is being perceived must *be perceived as being in the object*—while not insisting that it is *ontologically* in the object.[42]

POSTSCRIPT

This essay has explored the role of imagery in diverse modes of learning. In every mode the image has a central role, for it springs from the deepest roots of meaning. These images of feeling connect the cognitive and emotional aspects of life and learning—whether it be learning of language skills or appreciation of value. The arts are the most direct route to what Langer called the "forms of feeling."[43] The language of art, as she points out, is a form of presentational rather than discursive discourse. The fact that this language can be taught virtually constitutes an obligation to teach it to all who attend school.

The quality of life is measured by the repertory of feeling that pervades it. Life is rich if the repertory of feelings is large and the discrimination among them fine. Life is coarse, brutish, and violent when the repertory is meager and undifferentiated. Aesthetic education's role in enlightened cherishing is to enlarge and refine the repertory of feeling. Moral reflection, critical thinking, and knowledge about the world also contribute to the enlightenment of cherishing, but aesthetic experience does its work in the domain of feeling, to enlighten us about the nature of feeling.

APPENDIX

Making an Informed Aesthetic Response[44]

I. Aesthetic Perception

A. *Sensory Properties*. First, carefully look and/or listen; note what actually exists within an object or event and then identify as completely as possible the character of its sensory properties (qualities that can be seen, felt, or heard):

In art, identify the nature of elements such as shapes (square-round), lines (thick-thin), values (dark-light), textures (coarse-smooth), colors (bright-dull), size (large-small), space (deep-shallow), etc.

In dance, observe body gestures (curved-angular), movements (fast-slow), space (open-contained), etc.

In drama, observe elements such as vocal qualities (cadence, quiet-shrill), body movement (fast-slow), costumes and sets (sober-bold, realistic-abstract), etc.

In music, identify the nature of aural qualities such as pitch (high-low), tempo (fast-slow), duration (long-short), dynamics (loud-soft), etc.

B. *Formal Properties*. Second, respond to ways in which sensory properties are organized within an object or event by identifying the character of its formal properties (try to answer the following questions as the work is experienced):

To what extent is each element necessary? What is the nature of the movement (real or imagined) from one part to another, which thereby contributes to a sense of evolution and unity? How is the sense of unity maintained, even though elements may vary? How is unity in variety achieved?

Are there some elements that are more dominant than others—a hierarchy of elements? Which elements appear to be most dominant, thereby contributing to the major theme? How is variety achieved in the repetition of these elements, so that thematic variation results?

How is equilibrium maintained between and among both similar and diverse parts, so that a sense of balance is created? What rhythmical qualities are created when mode of balance and thematic variation are combined?

C. *Expressive Properties.* Third, reflect upon both the nature of the existing sensory properties and the ways they appear to be organized and then speculate about the possible meanings of an object or event by identifying its expressive properties. Aesthetic objects and events possess presentational (faces, trees, environmental sounds, familiar movements, etc.) and/or metaphorical-symbolic characteristics that evoke responses from one's storehouse of images and, when combined with sensory and formal properties, translate into pervasive qualities, such as:

Mood language—nuances of feeling describable in terms such as *somber, menacing, frivolous,* etc.

Dynamic states—arousing a sense of tension, conflict, relaxation, etc.

Idea and ideal language—interpretations of social or psychological events and beliefs, and/or expressions of courage, wisdom, etc.

D. *Technical Properties.* Finally, one can also be attracted to an object or event and attempt to identify how it was created because of the significance of its technical properties. Attending to the extraordinary surface texture created by an impasto application of paint or the richly patterned sounds produced by the pizzicato plucking of violin strings are examples of reacting to the technical aspects of art forms. Knowing how something is made is often important to aesthetic perception; however, aesthetic responses and judgments can be made without such awareness if other properties are considered.

II. Aesthetic Criticism

A. *Historical.* Determining the nature and expressive intent of works of art within their historical context and in relation to school, period, style, and culture.

B. *Recreative.* Apprehending and relating imaginatively what the artist has expressed in a specific work.

C. *Judicial.* Estimating the value of works of art in relation to other works using three criteria: degree of formal excellence, truth, and significance.[45]

NOTES

1. R. M. Gagne lists eight types of learning: signal, stimulus-response, chaining, verbal association, multiple discrimination, concept learning, principle learning, and problem solving (*The Conditions of Learning* [New York, 1965], pp. 58–59).

2. For analytic descriptions of learning theories, see G. H. Bower and E. R. Hilgard, *Theories of Learning*, 5th ed. (New York, 1981).

3. W. Köhler, *The Mentality of Apes*, translated by E. Winter (New York, 1925), pp. 40–42.

4. E. R. Hilgard and G. H. Bower, *Theories of Learning*, 3rd ed. (New York, 1966), p. 231.

5. See H. S. Broudy, *Enlightened Cherishing: An Essay on Aesthetic Education* (Urbana, Ill., 1972), chap. 2.

6. A. Paivio, *Imagery and Verbal Processes* (New York, 1971), pp. 327–332, 344–347.

7. B. L. Bull and M. C. Wittrock, "Imagery in the Learning of Verbal Definitions," *British Journal of Educational Psychology* 43, no. 3, pp. 289–293.

8. P. R. Hanna and J. S. Hanna, *Teacher's Manual and Key for Building Spelling Power*, grade 7 (Boston, 1950).

9. Bull and Wittrock (note 7), p. 289.

10. For a bibliography on this topic, see M. C. Wittrock and S. Goldberg, "Imagery and Meaningfulness in Free Recall," *Journal of General Psychology* 92 (1975), pp. 137–151.

11. H. S. Broudy and J. Palmer, *Exemplars of Teaching Method* (Chicago, 1965), pp. 94–95.

12. Hume said, "Nothing is more dangerous to reason than flights of imagination"; yet he could also say that it is vital to knowledge (*Treatise of Human Nature*, book 1, pt. 4, sec. 7). For Kant, "The unity of apperception in relation to the synthesis of the imagination is the understanding" (*Critique of Pure Reason*, translated by N. K. Smith [London, 1929]).

13. An example of the freedom that the separation of word from referent makes possible is the controversy as to whether art that is labeled "boring" is really "interesting." Frances Colpitt devotes an essay to this subject, entitled "The Issue of Boredom: Is It Interesting?" in the summer 1985 *Journal of Aesthetics and Art Criticism* (43, no. 4, pp. 359–366). Assorted critics are quoted on both sides of the issue, but the most *interesting* feature of the essay is its demonstration that language can create its own reality. Thus the word *boredom*, if concentrated on, turns into its opposite, *interesting*.

All of which suggests a pharmaceutical theory of aesthetics—namely, that if a painting or a concerto sedates the listener or observer sufficiently, it is worth studying for its soporific properties and is therefore artistically good. Whatever else may be said on this topic, it provides a clear example of the creative power of the imagination that the ability to detach the symbol from its referent in reality provides.

14. S. T. Coleridge, *Biographia literaria*, edited by G. Watson (New York, 1965), p. 146.

15. Kant (note 12).

16. C. deDeugd, *The Significance of Spinoza's First Kind of Knowledge* (Utrecht, 1966), pp. 72–73.

17. H. S. Broudy, "On Knowing With," *Proceedings of the Philosophy of Education Meeting*, 1970, pp. 89–116.

18. A. MacIntyre, "Relativism, Power, and Philosophy," *Proceedings and Addresses of the American Philosophical Association* 59, no. 1 (September 1985), pp. 5–22.

19. F. Dretske, presidential address, *Proceedings of the Western Division of the American Philosophical Association*, April 26, 1985, pp. 23–24.

20. I. Berlin, *The Divorce Between the Sciences and the Humanities*, 2nd Tykociner Memorial Lecture (Urbana, 1974), p. 32.

21. C. Fries, *American English Grammar* (New York, 1940), p. 288. See also H. S. Broudy, "Research into Imagic Association and Cognitive Interpretation," *Research in the Teaching of English* 7, no. 2, pp. 240–259.

22. J. F. Herbart, *Letters and Lectures on Education*,

translated by M. Felkin and E. Felkin (Syracuse, N.Y., 1898), pp. 147–148.

23. Reprinted with permission of Macmillan Publishing Co. and A. P. Watt Ltd., on behalf of Michael B. Yeats, Ann Yeats, and Macmillan London Ltd., from *The Collected Poems of W. B. Yeats*, p. 191. Copyright 1928 by Macmillan Publishing Co., renewed 1956 by Georgie Yeats.

24. Broudy and Palmer (note 11), chap. 2 and passim.

25. Kant (note 12).

26. J. P. Dougherty, "Substance as Controlling," in *Essays Honoring Allan B. Wolter*, edited by W. A. Frank and G. J. Etzkorn (Saint Bonaventure, N.Y., 1985), pp. 117–129.

27. J. H. Pestalozzi, *How Gertrude Teaches Her Children*, translated by L. E. Holland and F. C. Turner (Syracuse, N.Y., 1894), p. 200.

28. J. A. Comenius, *The Great Didactic of John Amos Comenius*, translated by M. W. Keatinge (London, 1896), p. 204.

29. F. W. Froebel, *The Education of Man*, translated by W. N. Hailmann (New York, 1911), p. 168.

30. J. Dewey, *How We Think* (Boston, 1910).

31. R. H. Ennis, "Critical Thinking and the Curriculum," *National Forum* 65 (winter 1986). See also H. S. Broudy, B. O. Smith, and J. R. Burnett, *Democracy and Excellence in American Secondary Education* (Chicago, 1964), chap. 14.

32. W. H. Kilpatrick, "The Project Method," *Teachers College Record*, 1918, pp. 319–335.

33. D. W. Gotshalk, *Art and the Social Order* (Chicago, 1947), p. 3.

34. See H. G. Hullfish and P. G. Smith, *The Method of Education* (New York, 1961), and R. B. Raup et al., *The Improvement of Practical Intelligence* (New York, 1950). Paul Diesing discusses five types of rationality and decisions encountered in a social order (*Reason and Society* [Urbana, Ill., 1962]).

35. Dewey (note 30).

36. H. Hurt, *An Investigation into the Assassination of John Kennedy* (New York, 1986).

37. H. S. Broudy, "Case Studies in the Uses of Knowledge," 1982, sponsored by the Spencer Foundation (available through ERIC, 224–015, 1982).

38. M. R. Miles, *Image as Insight* (Boston, 1985), p. 64.

39. N. Anderson, "Mythological Messages in the A-Team," *English Journal*, February 1986, pp. 30–34.

40. S. M. Langer, *Philosophy in a New Key* (Cambridge, Mass., 1942); idem, *Feeling and Form* (New York, 1953).

41. From D. H. Parker, *The Analysis of Art* (New Haven, Conn., 1926); reproduced in M. Rader, *A Modern Book of Esthetics*, 3rd ed. (New York, 1960), pp. 323–331.

42. See Broudy, *Enlightened Cherishing* (note 5), pp. 75–76.

43. Langer, *Feeling and Form* (note 40).

44. Prepared by H. S. Broudy and R. Silverman.

45. Adapted from T. M. Greene, *The Arts and the Art of Criticism* (Princeton, N.J., 1940), reproduced in Rader (note 41), pp. 460–466.

HARRY S. BROUDY

Harry S. Broudy was educated in the public schools of Milford, Massachusetts, studied chemistry at MIT and the humanities at Boston University, and took his doctoral degree in philosophy at Harvard University in 1935.

While serving as a supervisor in the Massachusetts Department of Education, he became interested in the philosophy of education, which he subsequently taught in the Massachusetts State Colleges at North Adams and Framingham. In 1957 he was appointed professor of philosophy of education at the University of Illinois, where he became emeritus professor in 1972. He has been a visiting professor at a number of universities.

While at Illinois he conducted a doctoral seminar in aesthetic education, using a combination of formal study in aesthetics and "aesthetic scanning"—an approach to the analysis of works of art that was later incorporated in the curriculum of the Getty Institute for Educators on the Visual Arts. His *Enlightened Cherishing*, dealing with aesthetic education, was published as the Kappa Delta Pi Lecture in 1972.

Among Broudy's other publications are *Building a Philosophy of Education*, *The Real World of the Public School*, *Paradox and Promise*, and *Truth and Credibility: The Citizen's Dilemma*. He has been increasingly concerned with the diverse uses of schooling and especially with the arts as parts of general education. He has contributed numerous articles to philosophical and educational journals, and his book *On the Uses of Schooling*, to be published by Routledge and Kegan Paul, is now in press.